A
FISH
THAT'S
A
BOX

Folk Art from the

National Museum of American Art

Smithsonian Institution

M. M. Esterman

GREAT OCEAN PUBLISHERS

ARLINGTON, VIRGINIA

Special thanks to W. Robert Johnston and Lynda Roscoe Hartigan,
whose support and encouragement have helped make this book possible.

Made With Passion: The Hemphill Folk Art Collection at the National Museum of American Art
An exhibition at the National Museum of American Art, Smithsonian Institution, Washington, D.C.,
from September 22, 1990 through January 21, 1991. The exhibition was organized by Lynda Roscoe
Hartigan, National Museum of American Art. The collection is a gift to the Museum by Herbert Waide
Hemphill, Jr., and Museum purchase made possible by Ralph Cross Johnson.

All photographs are by Edward Owen, Michael Fischer and Eugene Young, Jr., and are copyright National
Museum of American Art, Smithsonian Institution. Catalogue information compiled by Lynda Roscoe
Hartigan, Andrew L. Connors, Elizabeth Tisdel Holmstead, Tonia L. Horton and Marjorie Zapruder.

For information contact: Great Ocean Publishers
 1823 North Lincoln Street
 Arlington, VA 22207

First Printing

Library of Congress Cataloging-in-Publication Data

Esterman, M. M.
A fish that's a box: folk art from the National Museum of Art, Smithsonian Institution / M. M. Esterman

 Summary: Presents thirty-five folk art objects from the National Museum of American Art with accompanying
text explaining the motives behind the creation of folk art: functional, recording, whimsical, and visionary.

 1. Folk art — United States — Juvenile literature. 2. Folk art — Washington (D.C.) — Juvenile
literature. 3. National Museum of American Art (U.S.) — Juvenile literature. [1. Folk art. 2. National
Museum of American Art (U.S.)] I. National Museum of American Art (U.S.)] II. Title

NK805.E88 1990 745'.0973'074753—dc20 90-3802

ISBN 0-915556-21-9

Printed in the United States of America

Do you ever wonder why the things you use every day look the way they do?

Every thing that people make — even things that come from factories — begins in somebody's imagination. Sometimes you need a new box, or a new chair. But you don't want something ordinary. You're one of a kind, and you want something nobody has ever seen before.

Why not a box that's a fish?

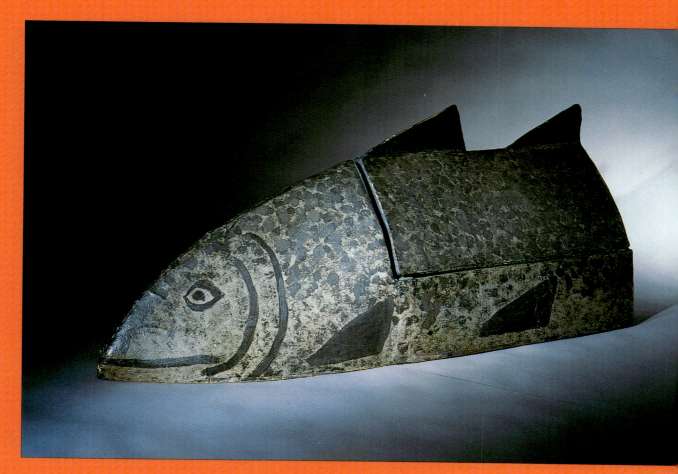

FISH-SHAPED BOX
Artist Unknown, early 20th century
painted wood, cardboard, and paper • *13½ x 30 x 10¼ in.*

Who says a chair
has to be square?

If you'd just love to have a table that's an airplane, with a propeller that turns, storage space in the cabin, and wheels that move, you're probably going to have to make it yourself.

This airplane has a wingspan of almost four feet. How tall are you?

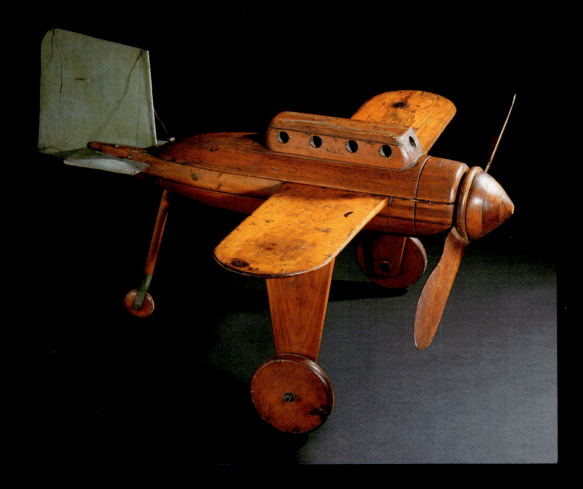

AIRPLANE
Artist Unknown, about 1933–1935
wood, painted metal, glass, and hardware
22 x 43⅝ x 43½ in.

You may want something very fancy,

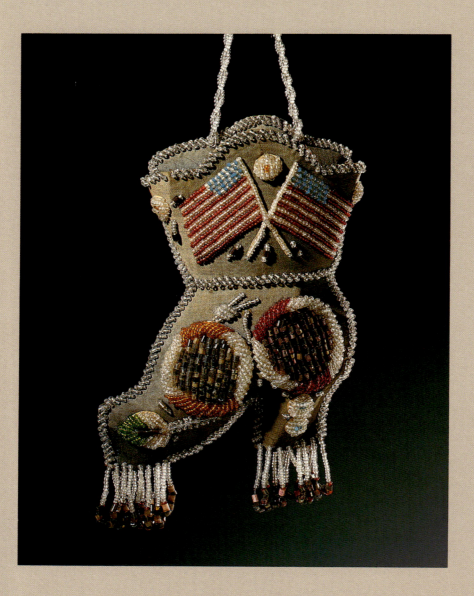

BEADED WHIMSY
Artist Unknown (Tuscarora Indian, New York State), about 1900
glass beads on cardboard-reinforced cotton with wool and sawdust • *15⅞ x 7 x 2⅜ in.*
This is actually a hanging whisk-broom holder, made by Iroquois Indians using traditional Native American skills. Such objects were produced for sale to tourists in the Niagara Falls region.

or customized — the way you like it.

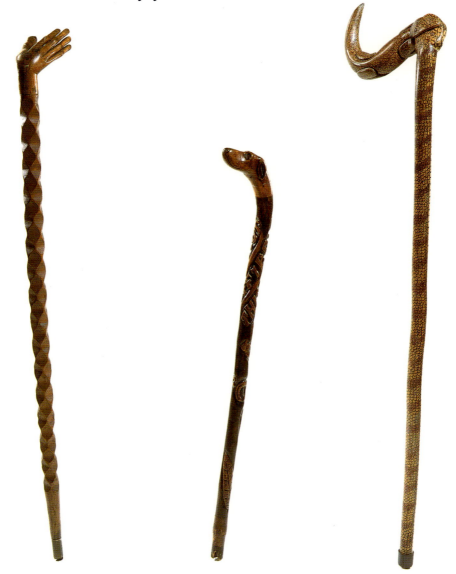

**CANE WITH
OUTSTRETCHED HAND**
Artist Unknown, probably
twentieth century
*carved and stained birch wood
with metal and rubber*
35¼ x 4½ x 1¼ in.

**DOG-HEADED CANE
INSCRIBED** *THIS CANE
CUT OFF 7 P.B.F. VA*
Artist Unknown, probably
twentieth century
*carved and stained wood
with iron nails*
28¼ x 4 x 1⅛ in.

**CANE WITH SNAKE
AND LIZARD**
Ben Miller (born 1917),
around 1968
*carved, stained, and
varnished dogwood or
white ash with plastic and
felt-tip pen*
38 x 8¼ x 1¼ in.

You may not think you're an expert, but you're going to do it anyhow.
You may discover what you're up to as you go along.
That's part of the fun of it.

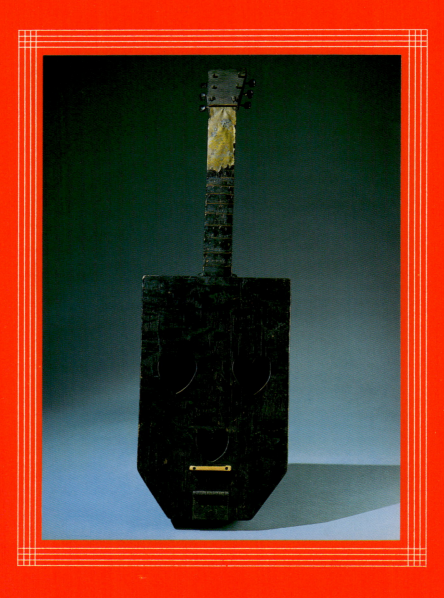

GUITAR ▪ Artist Unknown, 1920s–1930s
wood, metals, celluloid, and photograph ▪ *34¾ x 10⅞ x 4¼ in.*
The maker of this homemade, working instrument added some very personal notes to the back: a
small framed photo of a man standing in front of the George Washington Bridge in New York, a
brass scene of a Chinese garden, and a little hinged door that covers two compartments.

When you let your imagination go to work on even an ordinary thing you make it your own.
Once a pin cushion, now a PIN THRONE.

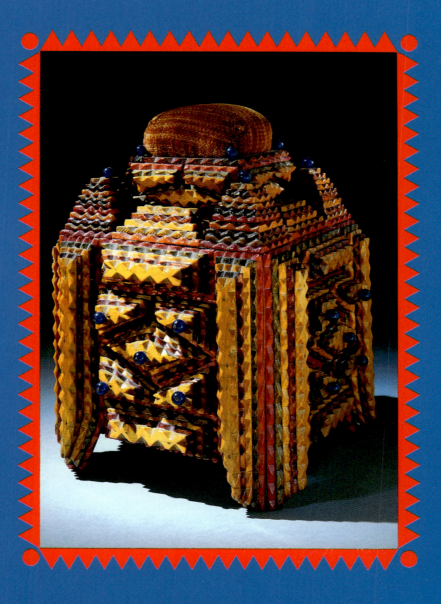

"CIGAR BOX" PIN CUSHION
Artist Unknown, 1880–1920
carved, stained, and varnished wood (from cigar boxes), glass beads, and velvet
12⅛ x 10 x 10 in.

Sometimes you need a sign or a symbol to show what you do, or what you sell.

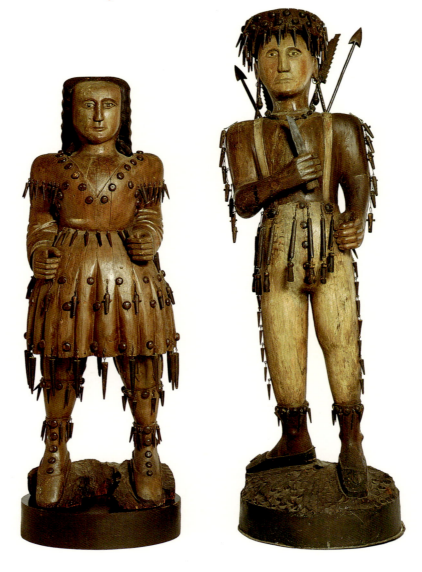

INDIAN TRAPPER AND INDIAN SQUAW
Artist Unknown, 1850–1890 ▪ *carved and painted wood and metal*
trapper: 60½ x 20 x 19 in. ▪ *squaw: 48¾ x 16¾ x 16¼ in.*
"Cigar Store Indians", as they were called, were first carved in Europe in the early 1600s, to advertise tobacco which was then being introduced from the New World. The carver of these two imaginary Indians used cone-shaped wooden bottle plugs to suggest buckskin fringes, and added a fancy pair of high-buttoned shoes for the lady.

So everyone can see,

OPTICIAN'S SIGN
Artist Unknown,
20th century
metal with electrical sockets
12 x 24⅜ x 2 in.

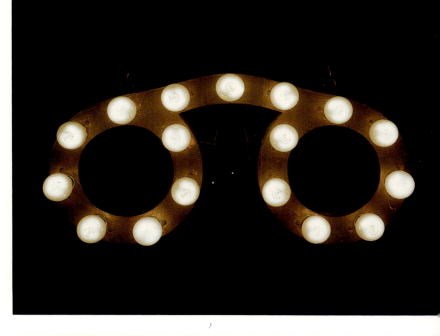

And want to do business with you.

BICYCLE SHOP SIGN
Louis Simon (1884–1970),
early 1930s
wood, bicycle parts, marbles,
and metal
34½ x 14 x 23½ in.
Louis Simon was a champion
motorcycle racer who also
invented and patented
improvements for cycles. He
opened his first motorcycle shop
in Brooklyn, New York, in 1912,
and carved his first figure of a
boy riding a bicycle in 1922 when
be began selling and repairing
bicycles. One of his signs had a
motor that turned the wheels,
making the legs of the rider go
up and down.

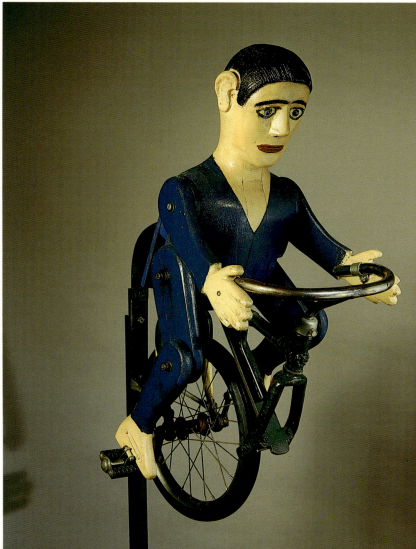

Maybe a little monkey business?

MONKEY TRADE SIGN ▪ Artist Unknown, about 1930–1950
glass tubing containing argon gas and mercury, black paint, electrical tape and transformer
32⅛ x 19⅝ x 1⅞ in.

Sometimes you want to make something you've seen, something that's so beautiful you have to make a picture of it.

You might keep the memory of a certain place or time in a picture you can take with you.

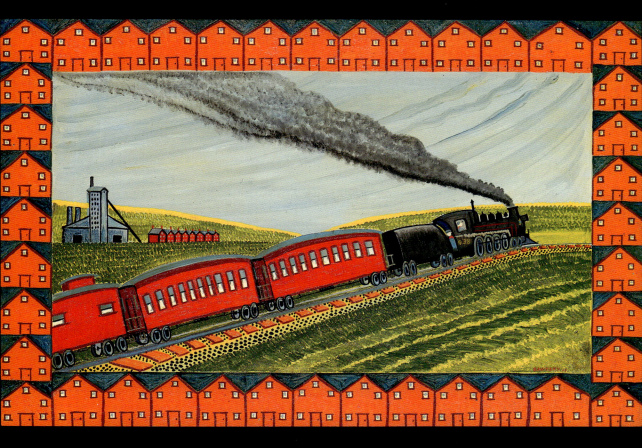

TRAIN IN COAL TOWN · Jack Savitsky (born 1910), 1968
oil paint on masonite · *31¼ x 47¾ in.*
Jack Savitsky worked in Pennsylvania's coal mines for almost forty years before an accident forced him to retire in 1959. This painting shows a coal-fired train bringing miners to the coal town where the artist was raised in a company-owned house like the ones in the border of the picture.

There's someone you love and respect, and you want to hold on to them forever.

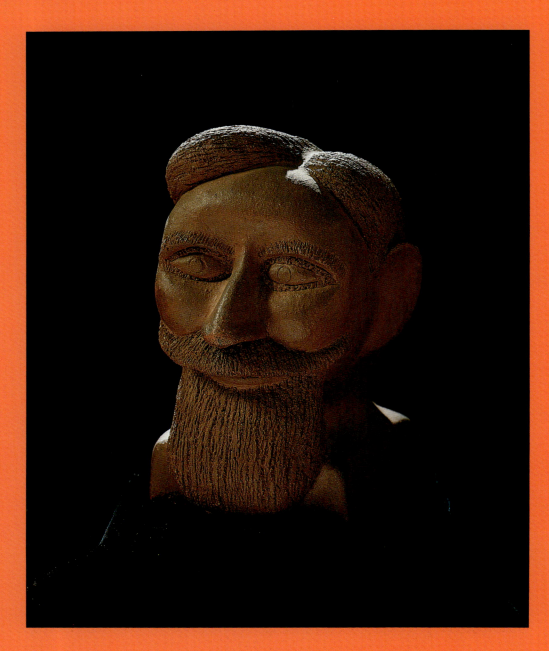

BRICK PORTRAIT BUST
Artist unknown, late 19th – early 20th century
fired clay brick ▪ *7⅜ x 4⅞ x 6⅛ in.*

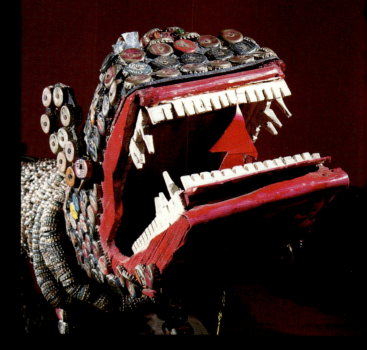

There is plenty of stuff around to make things with. It isn't hard to find. Maybe you've been saving it for a long time and suddenly you know what to do with it.

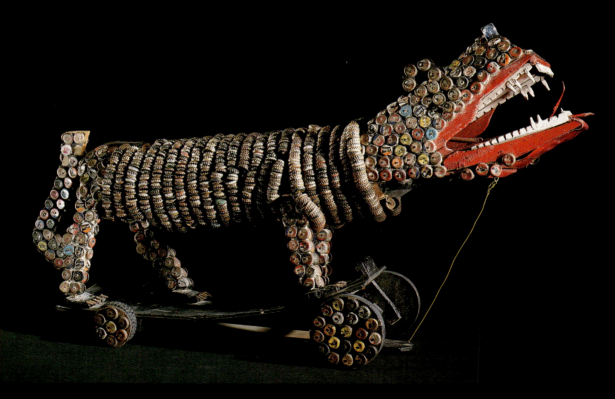

BOTTLECAP LION ▪ Artist unknown, completed after 1966
wood, bottlecaps, metal parts, fiberboard, plastic wheels, and flashcube ▪ *29¼ x 49½ x 15 in.*
Artists have been using these nonreturnable, nonrefundable bottlecaps as raw material for craft and art projects since they were first perfected in 1891. This lion's mouth is rigged to open and close by pulling a wire.

It may have looked like trash before,
but you can make it into . . . Bing Crosby!

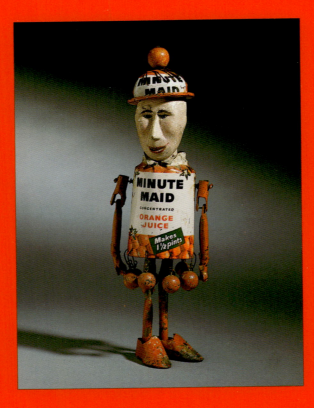

BING CROSBY
Artist unknown, around 1950
Minute Maid orange juice can, painted wood, and metal
10½ x 3½ x 2¾ in.
Popular singer and movie star Bing Crosby is seen here as the very product he advertised.

Give it some real life.

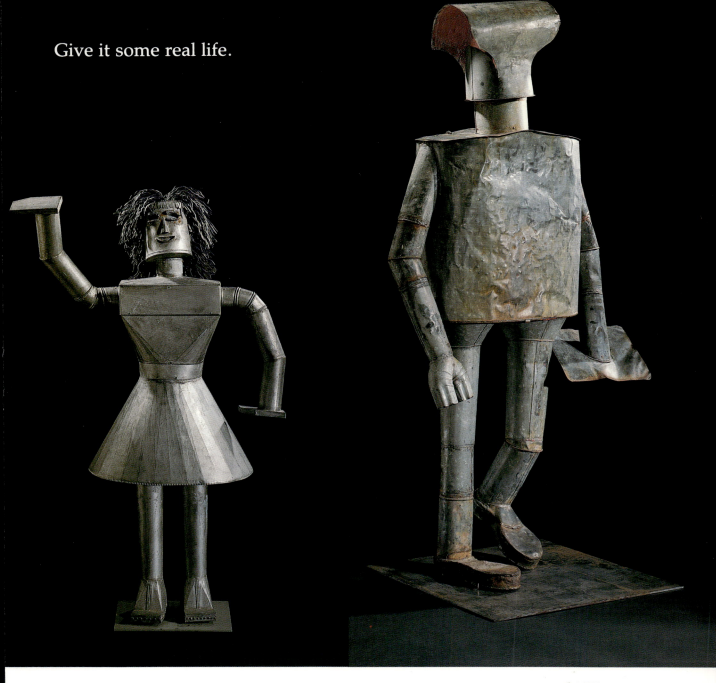

MARLA ▪ 1982
galvanized iron ▪ *59 x 38½ x 14¾ in.*
Irving Dominick (born 1916) began working in the family sheet metal trade in the Bronx, New York, after school and on Saturdays. After a lifetime creating ductwork for heating and air conditioning systems, roofing, and gutters, he began to branch out into imaginative objects. The model for this statue was his ten-year-old granddaughter, Marla.

GALVANIZED MAN ▪ around 1950
galvanized iron ▪ *78 x 37¼ x 20¾ in.*
Gerald McCarthy placed his larger-than-life figure outside his small shop in Ogdensburg, New York. Painted across the iron man's chest were the words "Plumbing, Heating, Cooling," to advertise the business, while the sculpture itself demonstrated his maker's skills.

You can take the meaningful things in your life, the odds and ends of memories and make them into one unforgettable object, something you can't walk away from.

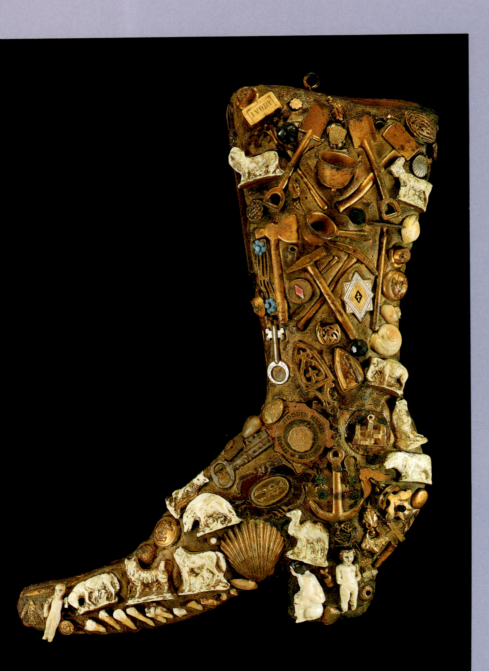

MEMORY HIGH-BUTTONED SHOE
Artist unknown,
early 20th century
*masonite with composition
dough embedded with metal,
plastic, glass and wood objects,
shells and teeth, gilded with
gold paint*
15½ x 12⅜ x 2⅜ in.

ROOT MONSTER ▶
Miles Burkholder Carpenter
(1889–1985), 1968
*carved and painted tree roots
with rubber, metal, and string*
22⅝ x 28⅝ x 28¼ in.
An experienced
lumberman, Miles
Carpenter collected fallen
branches and exposed roots
in the area of his Waverly,
Virginia, home, and also cut
trees into thick planks as
raw materials for his
carvings. He said, "there's
something in there, under
the surface of every piece of
wood. You don't need no
design 'cause it's right
there, you just take the bark
off and if you do it good
you can find something."

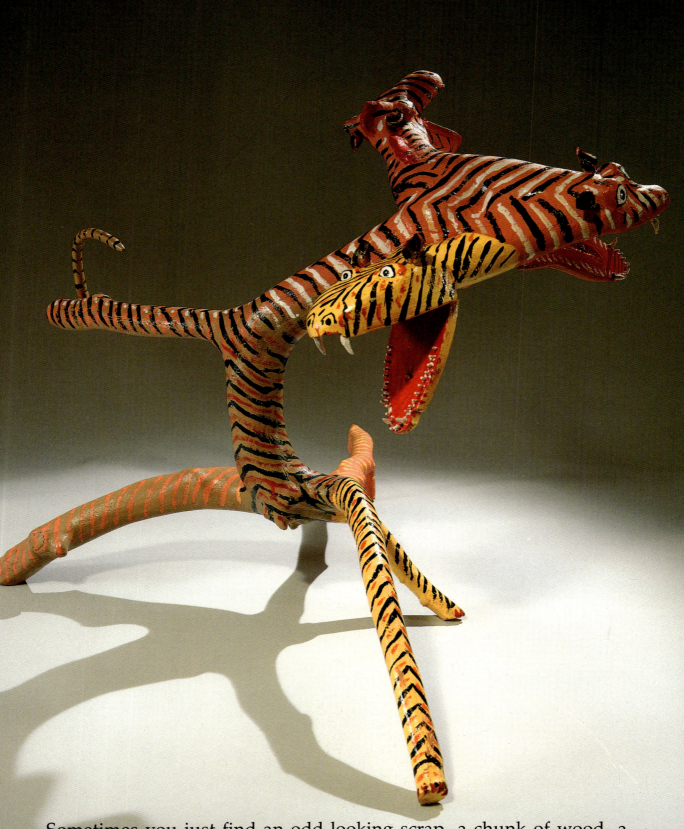

Sometimes you just find an odd looking scrap, a chunk of wood, a funny rock, and see a form struggling to get out. You can help it along.

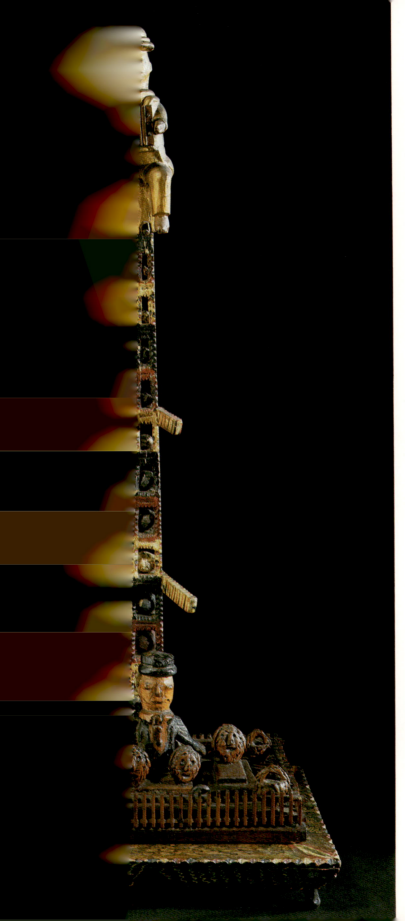

Sometimes you just want to make something that's fun to look at, that will make people laugh.

ACCORDION PLAYER
Benniah G. Layden
(1875–1968), around 1910
*carved and painted wood
and peach pits*
30⅛ x 12 x 8 in.

Or wonder.

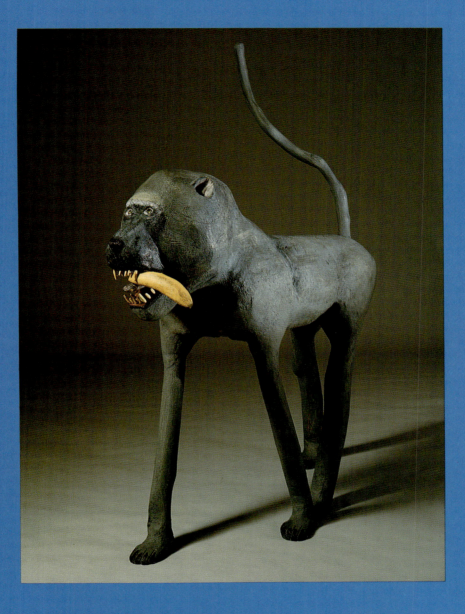

BABOON ▪ Felipe Benito Archuleta (born 1910), June 2, 1978
carved and painted wood with glue and sawdust ▪ *41¾ x 69¼ x 16 in.*
When Felipe Archuleta wants to carve an animal not found in his native New Mexico, he looks at pictures in children's books and magazines like *National Geographic*. But he definitely has his own ideas about what he will do. When art collector Herbert W. Hemphill, Jr., asked him to carve a monkey with a baby on its back, Archuleta responded with this stately baboon.

Or amaze them with some crazy contraption.

WHIRLIGIG WITH WITCH AND HORSE ▪ Charlie Burnham (dates unknown), 1918
painted metal and wood ▪ *25½ x 25 x 16¼ in.*
Wind turning the rear propeller on this whirligig drives the two men to raise and lower the propeller-topped water pump (made from a faucet). The Stars and Stripes serves as a wind vane, the dangling metal strips act as wind chimes, and the horse and witch with propeller arms are along for the ride.

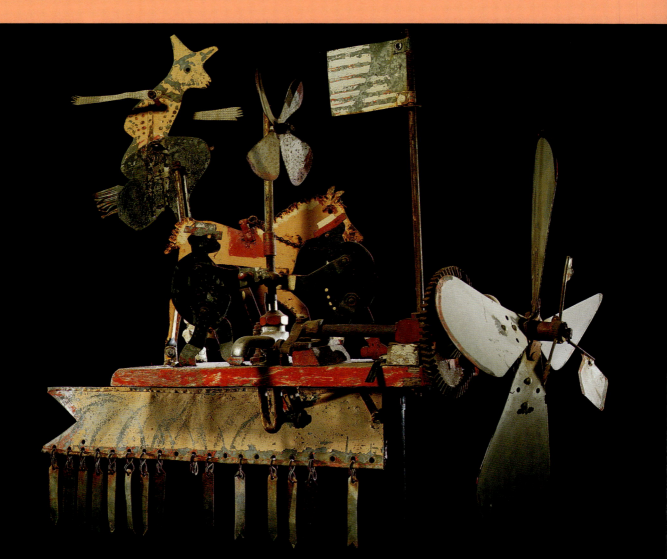

Or scare their pants off.

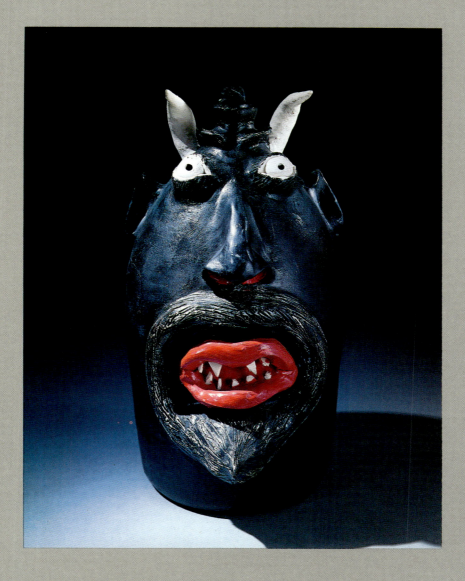

DEVIL FACE JUG ▪ Robert Brown (born 1951), 1960s–1970s
glazed and painted stoneware ▪ *13½ x 7⅜ x 9⅛ in.*
Face jugs are believed to have originated with slaves in South Carolina. This one was made by the descendant of a white family that has been making pottery in Georgia and North Carolina for eight generations.

Something that even scares you a little bit,
so you keep it in a special box to hide its power.

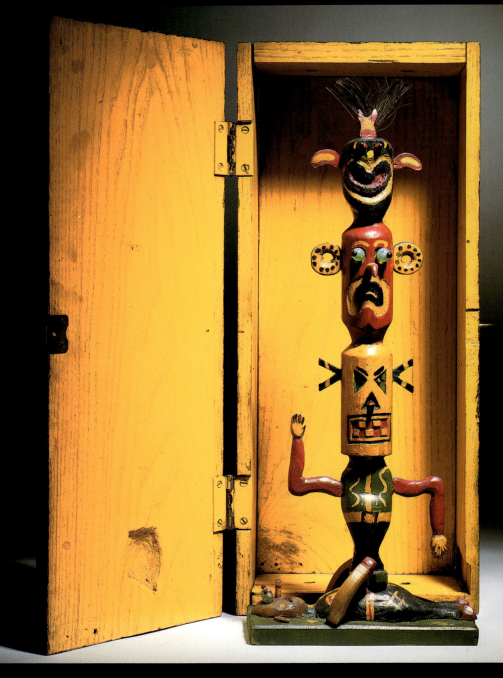

BOXED TOTEM ▪ Artist unknown, 20th century
carved and painted wood, glass, and bristle ▪ *21 x 8⅝ x 5⅝ in.*

Or get people to pay to see it.

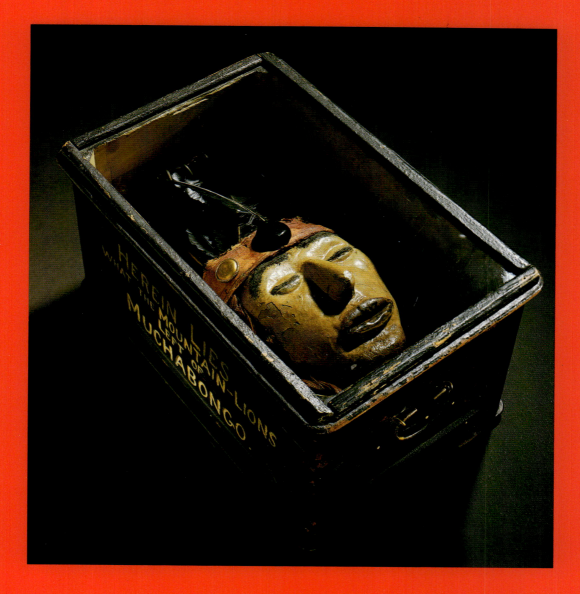

HEREIN LIES WHAT THE MOUNTAIN-LIONS LEFT OF MUCHABONGO.
GONE TO THE HAPPY HUNTING GROUND, WHERE GAME IS EVER PLENTIFUL,
AND THE WHITE MAN NEVER INTRUDES
Artist unknown, early 20th century • *carved and painted wood and plaster, synthetic fiber and*
buttons, wool, cotton, feathers, and shell • *9¾ x 17¾ x 11¾ in.*
The remains of the imaginary Muchabongo were typical of the exotic, often gory, and usually
fake exhibits displayed in traveling carnival shows and museums between 1890 and 1920.

Every story — no matter how old, or how new, no matter how familiar — we each see it our own way.

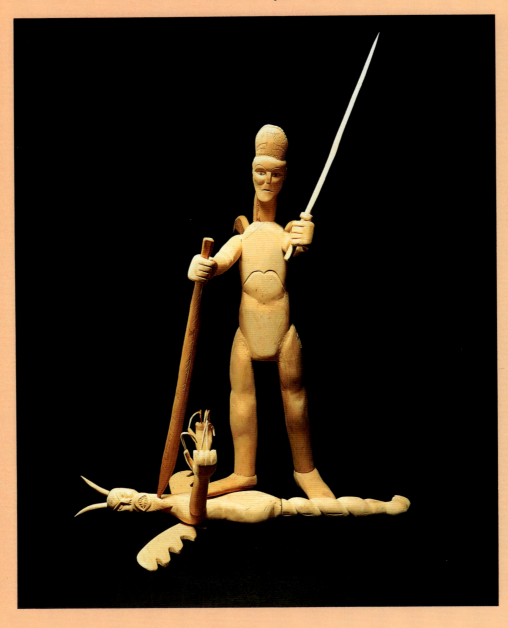

SAINT MICHAEL THE ARCHANGEL AND THE DEVIL
George López (born 1900), around 1955 ▪ *carved wood* ▪ *48 x 33 x 39½ in.*
Images of Saint Michael are found in all periods of Hispanic New Mexico carving. He is the protector of the just, the opponent of Satan, the patron of soldiers, and the guardian of young children.

Adam and Eve —

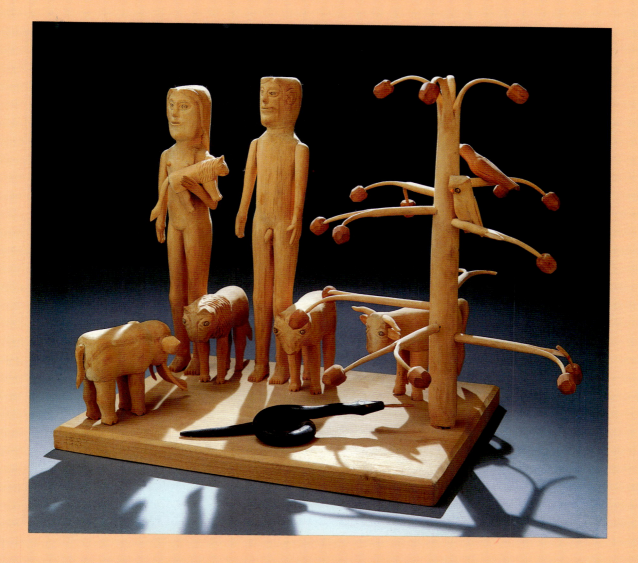

PARADISE
Edgar Tolson (1904–1984), 1968
pencil on carved and painted wood
12⅞ x 17 x 10 in.

Or the latest news —

How do you see them in your mind's eye?

GERALD FORD TOTEM POLE
Edward A. Kay (1900–1988), 1974
carved, painted, and turned wood, with metal, painted
modeling compound, printed papers and adhesive stickers,
wishbone, stamp, tacks, and safety pin
91 x 12½ in.
Edward Kay began to carve totem poles and other
complex figures during Prohibition when he traded a
fifth of whiskey for some woodworking tools. Until
1977, when he moved into an apartment, more than
100 totems stood outside his home in Michigan.
The figures on this 7½ foot high figure are, from
top to bottom: President Ford in his University of
Michigan football uniform, the U.S. Capitol, Vice
President Nelson Rockefeller, Secretary of State Henry
Kissinger, and President Nixon, his lips sealed with a
safety pin.

KENNEDY CAISSON
Marshall B. Fleming (born 1916), 1964
carved and painted wood, leather, wire, metal, printed
paper, paperboard, cloth, pen and pencil
20¾ x 43 x 10¼ in.
The moving and dignified funeral for assassinated
President John F. Kennedy had a deep impact and
left a vivid memory with all those who saw it,
including the millions who viewed it on television.

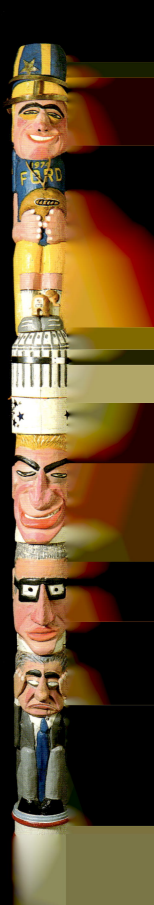

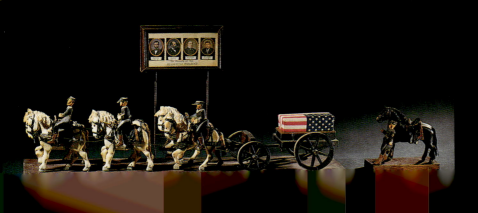

And what about the stories no one knows but you, a fantasy that you can bring to life, a vision of power or things to come?

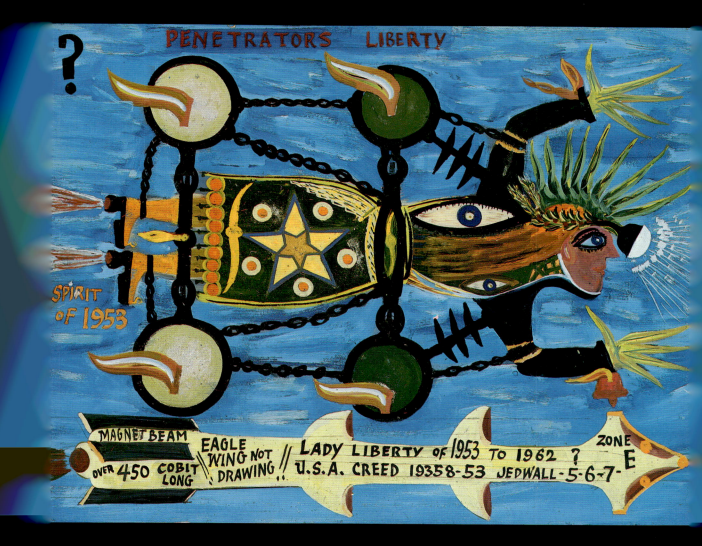

LADY LIBERTY OF 1953 TO 1962?
"Peter Charlie" Boshegan (born Armenia, date unknown, moved to USA 1903, died 1962), around 1962
house paint, metallic paint, and pencil on paperboard ▪ *22⅝ x 28½ in.*
Often just called "Peter Charlie," Boshegan worked as a handyman and housepainter in Leechburg, Pennsylvania. He lived a solitary life, and his activity as an artist was not discovered until after his death, when sixty-nine of his paintings were found in a garage he

A great idea, things no one else has seen . . . yet.

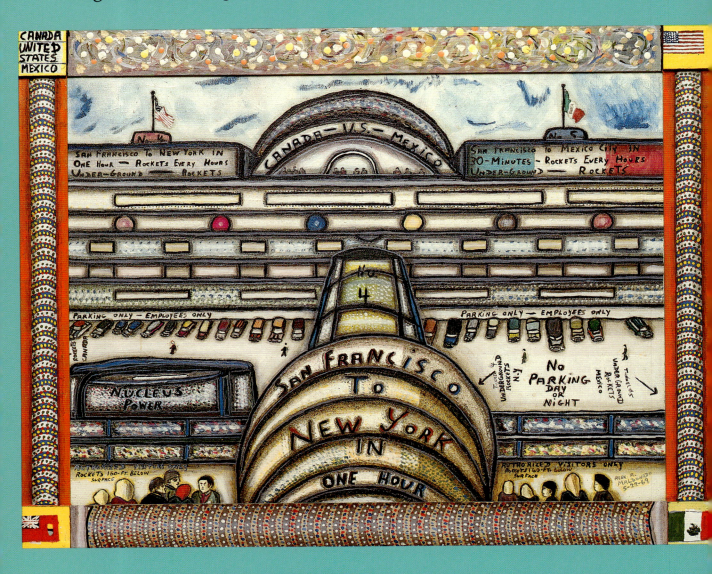

SAN FRANCISCO TO NEW YORK IN ONE HOUR
Alexander Aramburo Maldonado (1901–1989), May 22, 1969
oil on canvas and wood • *21½ x 27½ in.*
This artist was an immigrant from Mexico, a former boxer and retired shipyard worker.
Beginning in his earliest paintings (when he was already in his sixties) Maldonado expressed
his fantastic visions of a utopian future of space travel and pollution-free cities. He called
most of these works "21st Century Painting."

What are you keeping in your imagination?

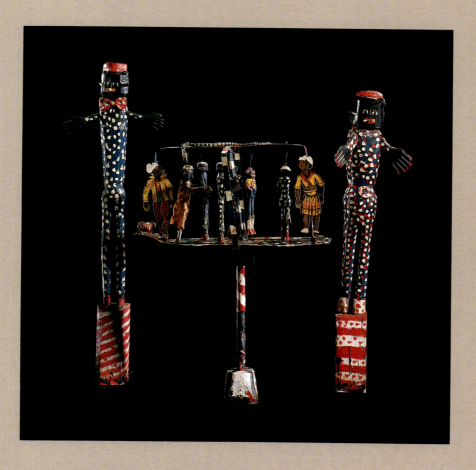

SET-UP WITH MUSICIANS AND DANCERS
Charlie ("Cedar Creek Charlie") Fields (1883–1966), around 1930–1960
carved and painted wood, metal, fabric, printed paper dolls, paper-mâché snake, plastic bulldog, hair, wire
Standing figures: 48¾ x 14¾ x 5⅜ in. and 44¾ x 12 x 10 in.
Frame with hanging figures: 37½ x 27 x 12¼ in.
Charlie Fields was an eccentric bachelor who lived with his mother on the family's tobacco farm in Cedar Creek, Virginia. After his mother's death in the 1930s, he began the decorating and building projects that occupied his spare moments for the remainder of his life. Fields completely repainted his house several times in various patterns including checker board, wavy lines, and stripes. His favorite pattern was polka dots (especially the patriotic red, white and blue), which covered all furnishings, including the coal stoves, bed, walls, and floors inside. Outside, whirligigs, model planes with doll passengers, a suspension bridge over a creek, and a Ferris wheel were similarly decorated. The outside was illuminated year round by Christmas lights. On Sunday afternoons, Charlie Fields welcomed visitors, especially children, into his home and yard while dressed in his suit, shoes, and hat — all painted with polka dots.

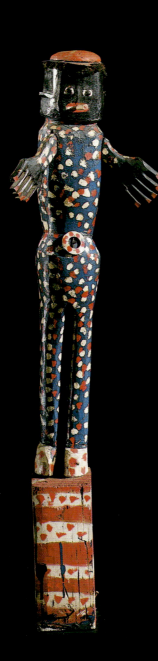

When you make something
new, you can see how your
imagination works.

You may surprise yourself.

You can add something
new to the world.

You might paint your world
with polka dots,
and invite other people in.

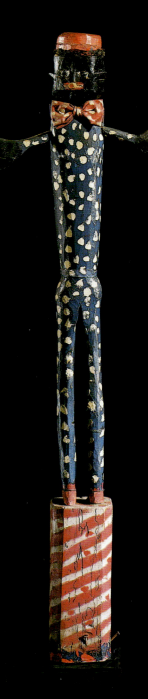